ANDY WARHOL

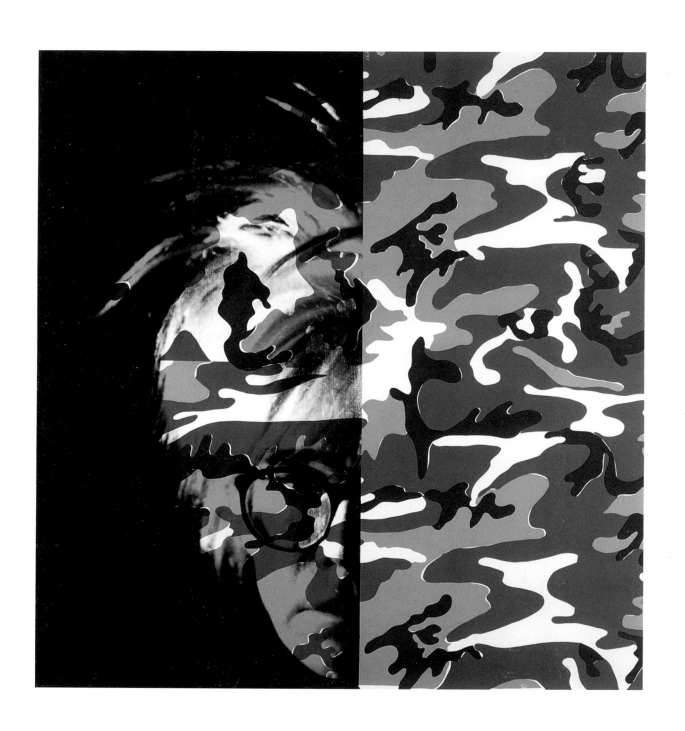

ANDY WARHOL
Abstracts

Edited by Thomas Kellein
With contributions by Callie Angell and Thomas Kellein

Prestel

Munich – New York

First published in German on the occasion of the exhibition "Andy Warhol abstrakt" (September 19–November 14, 1993), organized for and by the Kunsthalle Basel in cooperation with The Andy Warhol Foundation for the Visual Arts, Inc.
Further venues: MAK – Österreichisches Museum für angewandte Kunst, Vienna (December 1, 1993–February 20, 1994), Kunsthal Rotterdam (March 6 – May 8, 1994), Rooseum, Malmö (May 21–July 31, 1994), and IVAM – Centre Julio González, Valencia (September 15–November 27, 1994).

Front cover: *Egg Painting,* 1982, silk-screen ink on synthetic polymer paint on canvas, 90 x 70 in. (229 x 178 cm)
Back cover: *Egg Painting,* 1982, silk-screen ink on synthetic polymer paint on canvas, 90 x 70 in. (229 x 178 cm)
Frontispiece: *Camouflage Self-Portrait,* 1986, synthetic polymer paint and silk-screen ink on canvas, 80 x 80 in. (203 x 203 cm)

Photographic credits:
Photographs on pp. 28 and 40 courtesy Thomas Ammann Fine Art, Zurich; all illustrations of works belonging to The Andy Warhol Foundation for the Visual Arts, Inc., New York, courtesy Patty Wallace.

Prestel-Verlag, 16 West 22nd Street
New York, NY 10010, USA
Tel. (212) 627 8199; Fax (212) 627 9866
and Mandlstrasse 26, 80802 Munich, Germany
Tel. (89) 38 17 09 0; Fax (89) 38 17 09 35

Distributed in continental Europe by Prestel-Verlag
Verlegerdienst München GmbH & Co. KG,
Gutenbergstrasse 1, 82205 Gilching, Germany
Tel. (8105) 38 81 17; Fax (8105) 38 81 00
Distributed in the USA and Canada on behalf of Prestel by te Neues Publishing Company, 16 West 22nd Street, New York, NY 10010, USA
Tel. (212) 627 9090; Fax (212) 627 9511
Distributed in Japan on behalf of Prestel by YOHAN Western Publications Distribution Agency, 14-9 Okubo 3-chome, Shinjuku-ku, Tokyo 169, Japan
Tel. (3) 32 08 01 81; Fax (3) 32 09 02 88
Distributed in the United Kingdom, Ireland, and all remaining countries on behalf of Prestel by Thames & Hudson Limited, 30-34 Bloomsbury Street, London WC1B 3 QP, England
Tel. (71) 636 5488; Fax (71) 636 1695

Copyedited by Simon Haviland
Thomas Kellein's essay translated by Steven Lindberg
Reproductions by Fotolito Longo, Frangart, Italy
Typeset by Setzerei Vornehm GmbH, Munich
Printed by Peradruck, Gräfelfing
Bound by MIB Conzella, Pfarrkirchen

Printed in Germany

ISBN 3-7913-1328-2 (English edition). ISBN 3-7913-1332-0 (German edition)

Contents

Foreword

This exhibition of "abstract" works from Andy Warhol's estate goes back to an idea by Kasper König. He gave the impetus to this tour of largely unknown paintings from Warhol's last years of activity and established the first contacts with the MAK–Österreichisches Museum für angewandte Kunst (Austrian Museum of Applied Arts) in Vienna and the Rooseum in Malmö. We would also like to thank him for his suggestion of showing the paintings together with the first "minimalist" films.

The overwhelming majority of the paintings are on loan from the Andy Warhol Foundation for the Visual Arts, New York. We have been superbly advised and supported from the very beginning by Vincent Fremont, Exclusive Agent, Timothy Hunt, Curator, Jane Rubin, Administrator of the Collections, and Archibald L. Gillies, President of the Foundation. We should also like to thank Kynaston McShine, Senior Curator of the Museum of Modern Art, New York, whose support for this project has been most helpful. John G. Hanhardt, Curator of the Film and Video Department, Callie Angell, Adjunct Curator of the Andy Warhol Film Project at the Whitney Museum of American Art, New York, and Dora Meyers-Kingsley, Director of the Film Department of the Andy Warhol Foundation, provided authoritative advice for the selection of Warhol's early films. The latter are not just shown as a supplementary program, but continuously, as early "abstract" pictures.

We are grateful to Corinne Baier and the team from the Kunsthalle Basel for the organization of the exhibition. Last but not least, we should like to thank Thomas Ammann, who died recently: he was responsible for two important loans, which were indispensable to the project.

Thomas Kellein
Kunsthalle Basel

Peter Noever
MAK–Österreichisches Museum für angewandte Kunst, Vienna

Wim van Krimpen
Kunsthal Rotterdam

Lars Nittve
Rooseum, Malmö

Vicente Todoli
IVAM Centre Julio González, Valencia

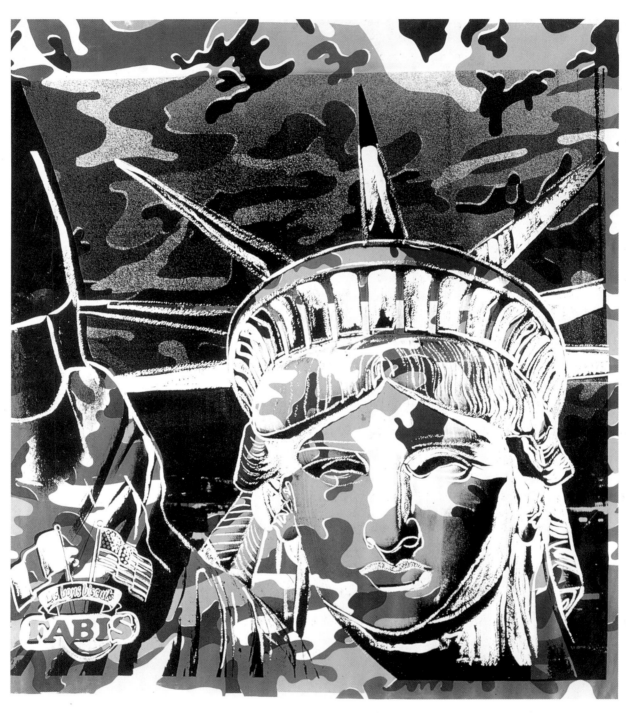

Fabis Statue of Liberty. 1986.
Synthetic polymer paint and silk-screen ink on canvas. 80 x 80 in. (203 x 203 cm)

Thomas Kellein

Pleasure in Mechanics
Warhol's Abstract Work

Between 1977 and 1986, Andy Warhol produced six series of paintings of various sizes, which—with a bit of caution and a trace of humor—can be characterized as his "abstract" work. Unusual for Warhol, they were not based on photographs of popular personalities, products, and events, but rather on the wish to paint in abstract patterns. As early as *Thirteen Most Wanted Men*, which had to be covered with a veneer of silver paint during the 1964 World's Fair in New York, an "abstract" Warhol had sporadically become familiar.[1] In their large formats and weightiness, many of his silk-screen paintings from 1962 on referred to the "big canvas" of Abstract Expressionism.[2] But not until the *Oxidations, Shadows, Eggs, Yarns, Rorschachs,* and *Camouflages,* six relatively unfamiliar series of works from the last ten years of his life, did Warhol interrupt his "virtual history of the world in the last quarter century"[3] and declare a break from his history painting. The "major journalist" and "media master,"[4] who was active both as a "documentary realist"[5] in the Brechtian sense and a "court painter to the 70s,"[6] began an unofficial, cynical game in his above-mentioned "abstract" series, which shows his own idea of art to be one of nihilism and satire.

In the fifties, Warhol was a success as a commercial graphic artist "with butterflies, ladies' shoes, and boys"[7] much to the envy of his later colleagues. With the *Campbell's Soup Cans, Dollar Bills, Coca-Cola Bottles,* portraits of *Elvis, Marilyn,* and *Liz,* and the *Disaster* and *Flower* paintings, he made the major contribution to the history of Pop Art from 1962 on. His announcement, on the occasion of his second solo exhibition in Paris in 1965, that he would give up painting, helped to feed a belief in the exclusive radicalism of his work, which supplanted all the traditional approaches to art. Together with his underground films, which he had begun in 1963, the subsequent concerts with the rock group The Velvet Underground, and the celebrity magazine *Interview,* which he founded in 1969, the entire artistic production from the "Factory" gives the impression that Warhol had grown in just a few years from a draftsman, designer, and painter to a

director of culture of great political significance. Rainer Crone remarked apodictically in the first monograph on Warhol in 1970 that Warhol was "North America's most important artist in the history of the fine arts and film."[8] This political significance nevertheless remained difficult to fathom.

The reaction of the art world to the large-format *Mao* paintings of 1972 was one of gratitude and of exitement about a return to paintings, paintings of a sort that revealed an expressive brush technique on the canvas beneath the silk-screen ink.[9] In the last fifteen years of his life, Warhol's impresario role dominated his painted œuvre to such an extent that his ongoing images on canvas of consumer objects, politicians, stars, and historical subjects appeared alongside the products of a photographer, film and television producer, editor, and paid model. Increasingly, many paintings in his artistic chronicle showed signs of individualistic brushwork, of playfulness, and of contradictions, as they took their place in the framework of a complex marketing of art. Warhol culture, whose substance and significance are a matter of debate even today, attained the end-in-itself character of a large production apparatus, as the artist became possessed by an 'abstract' endeavor to achieve success.

As a painter, Warhol usually broke down "familiar" images and painting techniques into stencilled fragments of lines, coarse halftone dots, and floating planes of color. The chosen motif was robbed of its context and its typical details and transferred to the canvas from an ephemeral manifestation in a magazine, on television, or in the cinema. The viewer of the art object was thus confronted with known, popular motifs from the culture of everyday life, which, though they were preserved artistically, did not look highly "finished" in terms of a glossy printing technique or a meticulous hand-painting. Warhol had evolved into a cultural politician, who, even if he was not promoting particular products, was visually and verbally promoting consumption and the era of overproduction.

The *Del Monte Peach Halves* of 1960 (Staatsgalerie Stuttgart) already referred to a common trade name and presented it—with the help of several surfaces painted with a muted expressiveness—as the mark of a consumer article. Warhol, however, broke off the imitation at a halfway point and also endowed the perspectives of the framing surfaces with imperfections. Thus, neither the chosen subject nor the artwork itself could really be objected to as a message. Obviously, both derived from the same culture.

In other early works, too, goods and their accompanying price tags appear distorted and visually incomplete, so that the painting and its motif could always be understood as an ambivalent signal, a story with an unfamiliar ending. The various *Dollar Bills* of 1962, which presented the fronts and backs of the American currency lined up dozens of times across the canvas, created a sensational effect as the "mechanical" reproduction of money and its lack of background. But Warhol had either deliberately distorted the imagery within the dollar bill with caricatures and delicate arabesques or printed the stencils noticeably askew with respect to the coordinate system of horizontal and vertical lines. From the perspective of documentary history painting, the result was neither dollar bills nor artworks. Rather, the techniques chosen by the artist undermined the succinctness of the object and raised it into a cultural domain of half-mechanical, half-handmade stencils and schematics.

Since Warhol's paintings from the very beginning were sometimes more than six feet high and since these disturbances in registration in many cases proved to be a principle of his work, the cause for the strange parallelism of art and reality appeared to be a coy methodology that deliberately operated with amateurish elements, which seemed to pay homage to the products and values of the age. As unambiguous as the artist's imitation of his subject may have been in his *32 Campbell's Soup Cans* of 1962 (Collection Irving Blum, New York)—and in creating a mise-en-scène from twenty-inch-high variants of products he was certainly ennobling his subject—it is significant that he modified their distinguishing characteristic, namely, the writing that identified the contents of each can, with letters that look neatly handpainted. The pseudomechanical copies of printed soup labels thus prove to result neither from expertise nor from a love of the motif. Rather, Warhol produced a discrepancy between external objects and their artistic assimilation, reflecting an inseparable mixture of his own and others' interests. The artwork indirectly demonstrated that the consumer reality with which one was inescapably confronted in overwhelming numbers should not be approached too closely and should be avoided in some fashion. Yet Warhol did not want to reject it—he was fascinated by its abstract vitality.

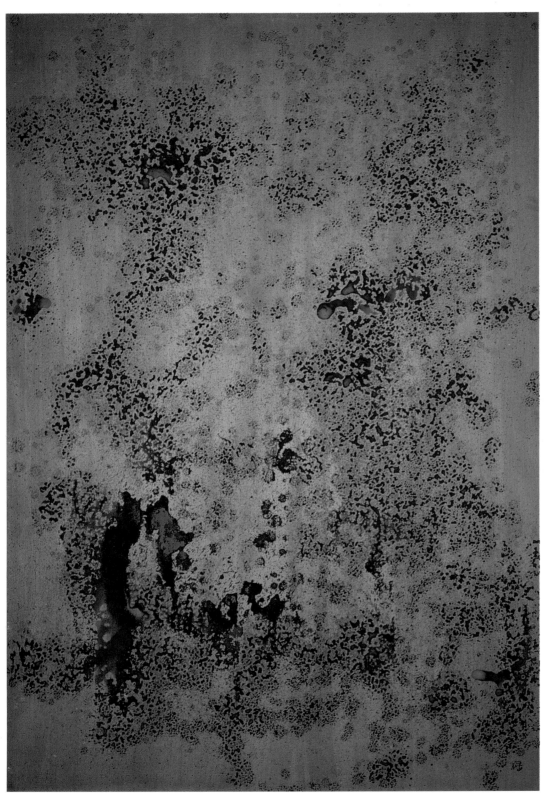

Oxidation. 1978.
Mixed media on copper metallic paint on canvas. 76 x 52 in. (193 x 132 cm)

During the student rebellions of the sixties, the "affirmative" or "pejorative" character of Warhol's apparently mechanical works was extensively debated in seminars and lecture rooms: "In lieu of expression and pictorial organization, he offers simple imitation; in lieu of personal style, objective printing methods; in lieu of aura, multiplications of the original...," as Peter Weibel wrote with admiration in 1968.[10] "Warhol revolutionized traditional aesthetics," pronounced Rainer Crone two years later,[11] without naming the major characteristic of his art, namely, the representation of inflated products and an embracing of overproduction. The emphasis placed on finding an instructive content in the numerous silk-screen paintings that appeared in the wake of the *32 Campbell's Soup Cans* of 1962 was based on a propitious error, which many of the artist's statements had suggested. The error—it had to do with his oft-cited indifference—was that, to use Crone's words: "Warhol's creativity was reduced to the selection of the subject of the painting."[12]

In a frequently mentioned interview with Gene Swenson in 1963, the artist gave the impression that he was happy that having abandoned his work in advertising he no longer had to "invent."[13] He took what was offered, in order to transfer it to canvas or film. Accordingly, Henry Geldzahler emphasized in 1964, in reference to the 16-mm film entitled *Sleep*: "Andy Warhol wants to keep his editing to an absolute minimum and allow the camera and the subject to do the work."[14]

In a fictitious interview with his assistant, Gerard Malanga, which was published in the winter of 1964–65, Warhol gave his profession as "factory owner" and his secret profession as "commercial artist." The very meager, consciously banal questions received cynical, existentialist replies; as usual, Warhol avoided opinions about the state of the world or declarations of his intentions. But he openly broke with a notion of virtuoso creativity and placed his emphasis on quantity: "Talented people . . . should not be allowed to be paid," he said, for example, "because they can do it so easy."[15]

To the extent that Warhol refused to give elucidations of content, his paintings seemed to have been produced by an unimaginative victim of the media, from a mechanical creature. With his shoulder-shrugging indifference, he gave the impression of being a melancholy Pierrot, who was conscious of the significance of his own actions, but did not want to face up to

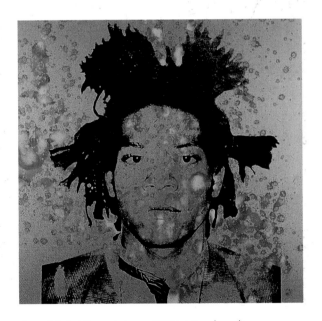

Jean Michel Basquiat. ca. 1982. Mixed media on metallic paint and silk-screen ink on canvas. 40 x 40 in. (101.5 x 101.5 cm)

them. Since his work continued to evolve in a direction in which small mistakes and visual distortions in the reproduction of the subject provided the characteristic element that passed without commentary, this attitude grew into a strategic calculation. As Geldzahler had noted about *Sleep*, one of the earliest films: "Minimal editing accounts for the roughness, the opposite of Hollywood's technical proficiency."[16] The lack of precision and a fixation with the subject was identified by outsiders with ingenuous stupidity, with aspects of the hippie scene, or with the consumption of drugs in the Factory. Warhol knew, however, that people were fascinated by his goods and by the roughness of his mechanics.

With his first European retrospective, which was organized in Stockholm in 1968, the superficiality of his paintings and their lack of meaning and content were applauded in Europe, too, as a stylistic means.[17] But Jürgen Harten noted, for example:

> *The way he crops his subject, the way he determines or approves the series, the size, the color of whatever he comes upon, it all proves once again that the technical manipulation is not a means to the end of the reproduction, but is rather the artistic basis for that which is represented.*[18]

During the course of the sixties, Warhol had developed a form of pictorial mechanics that deliberately avoided precision into a highly productive form of interacting with motifs from the media, which he then took from canvas to wallpaper and expanded to include other everyday items. Beginning in August 1962, with his first use of the photo silk-screen technique, he reproduced his subjects once, twice, four, or even dozens of times, rounded or with corners, smudged or blurred, side by side or overlapping, isolated or parcelled out as objects. The stylized mechanics and the unpolished schematization helped to rob these media images of the emotional power of public appearance and the gestures of fame. This brought an end to the association of stars and products with the magazines, posters, billboards, and TV programs in which they appeared, presenting an alternative in the form of Warhol's introduction of the subjects to the public of the art world. The emotional power found its way into the formats and the colors of the paintings, and the gestures reappeared in those strange deviations, behind which was an illusion of dilettantism. Warhol stood between the commercial "senders" and the art-loving "receivers" like a defective record-needle

that played the greatest hits on canvas, only with flaws, as if he were more interested in the scratches in the record than in the music. The dots of his silk screens were too large, the repeated rows of photographic images were crooked, the colors of the portraits and history paintings were usually a touch too garish or pale, and the arrangement of background colors emphasizing the facial features that were placed under the hair, eyes, or mouths of those portrayed were strikingly incongruent from the very beginning. The result was a nostalgic desire for consumer goods or stars: although our heroes were visibly damaged, there was nothing else to admire.

The extent to which pleasure in the aura of the mechanical was an artistic aim could be seen not only in the self-consciously large formats of the canvases but above all in the sheer number of paintings. In his provisional catalogue raisonné of 1970, Crone named some two thousand paintings for the period between 1962 and 1964.[19] The group of *Flowers*, begun in 1964, for which Warhol used a prize-winning amateur photograph, alone comprised some nine hundred works, which varied not only in the coloring of the motif, but also varied in size from 5 x 5 in. (12.5 x 12.5 cm) to 120 x 120 in. (305 x 305 cm). Just a few years later, the *Flowers* were available as an edition of prints, and as carpeting, followed after the artist's death by postcards, posters, calendars, and T-shirts.[20]

The imperfect and the peculiar became credible in large numbers and required some getting used to, as with any "new" paintings. This was an effect that was familiar to Warhol, especially from the weekly advertisements for shoes that he produced for the I. Miller Company in the fifties. The art-producing "machine" was not supposed to function like clockwork, but rather like an assembly line. The large quantities of pieces, the associated high turnover, and their measurable reputation were more important to him than the quality of the individual product. The goal was artistic production on the scale of a department store. The task was to collect the best-known motifs of mankind, put them "mechanically" on canvas, and market them with accompanying goods, just as the conventional media do. Insofar as this method began unquestioningly with the universally accepted ideals of popularity and robbed the ever-changing stars and products of their mode of existence and their historical context, Warhol's work had abstract characteristics from the very beginning—a "Factory," which entirely rejected the particulars and the individuality of its subjects, consolidated the "meaning-

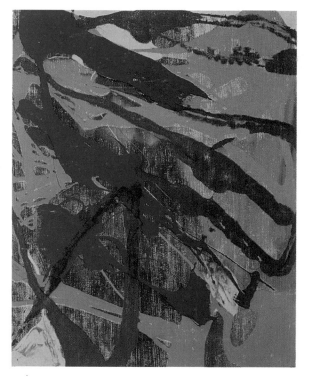

Untitled. ca. 1982. Synthetic polymer paint and silk-screen ink on canvas. 20 x 16 in. (51 x 40.5 cm)

ful" in culture as if in a fairy tale, and extracted the fame, like gold and silver, from the stream of images of everyday life.

Already by the mid-sixties, the older generation of the New York School indignantly observed that this practice had made Andy Warhol, and not Jackson Pollock or Willem de Kooning, "the most famous":

> He's a household word. He ran together all the desires of artists to become celebrities, to make money, to have a good time, all the Surrealist ideas, so Andy Warhol has made it easy. He runs discotheques. He does absolutely everything...[21]

Right up to the end, news of Warhol—whether of the portraits he made of Joseph Beuys, or of his collaborations with Jean-Michel Basquiat and Francesco Clemente—was received as a cultural sensation. The artist himself experienced the continual impetus of contacts and commissions as a fountain of youth.[22] After avoiding older and contemporary colleagues out of a fear of inferiority,[23] he turned to the younger generation of painters in 1980, including Basquiat, Clemente, Keith Haring, Kenny Scharf, and Julian Schnabel, in order to place himself in competition as an artist, and to measure the value of his own work at the start of a new decade: "I got so nervous thinking about all these new kids painting away and me just going to parties."[24]

Warhol admired the fame of colleagues significantly less than the success, measurable in riches, of film stars and producers like John Travolta or Sylvester Stallone.[25] From the editor of his diaries, Pat Hackett, we learned posthumously that, despite his constantly increasing recognition and his considerable wealth, he fought with wit and humor to the very end against the fear of going bankrupt with one of his numerous projects.[26] His employees and assistants were supposed to concern themselves primarily with portrait commissions, advertising income for *Interview*, paid fashion or film sessions, and the rental of his houses and apartments. That there were artists who considered themselves important even though they could not appear on Broadway, he dismissed laconically with the remark: "How can you be 'big' if you're *not working!*"[27]

Warhol never abandoned the primacy of turnover and the image of his own products. His famous maxim of 1963 that he wanted to be "a machine," together with the recommendation that "everyone should be a

machine,"[28] was coupled with a highly puritanical work ethic and the aspiration to maximized, frictionless productivity. Pablo Picasso left behind several thousand masterpieces after a long artistic life, Warhol said unashamedly in the sixties, and he would like to reach that number every day. With an eye to his work, he avoided sexuality, partnerships, and the desire for children all of his life. He took care of himself, fearful of disease and of death. The idea that all human beings should function like machines meant from his point of view that he observed the world and humankind, but did not want to carry the burden of their problems or get too close to them.[29] With disgust, he noted in his diary in 1977 that, on one of his regular visits to church, a bag lady had asked him for five or ten dollars, while he himself was "kneeling and praying for money."[30] The mechanics of art lured the world closer as in a display window whose glass Warhol allowed to dazzle the viewer. The method was sufficient to survive. He seems not to have believed that his works carried a message or had value in the traditional sense.

With the *Oxidations* or *Piss Paintings* from 1977 on, with an almost macabre irony, Warhol invited friends and acquaintances to step into the world of American "drip"-painting. Since the beginning of his career, he had observed with suspicion the cult around Pollock and the loutish behavior of many Abstract Expressionists.[31] The *Shadows* of 1978 and 1979, whose ephemerality is based on shadows cast by various objects on the wall in his studio, refer back visually to the calligraphic gestures of the paintings of Robert Motherwell and Franz Kline. The *Yarns* of 1983, a group of commissioned paintings for a Florentine textile company, were also a homage to the "all-over" painting of the New York School. They were followed, in 1984, by the large group of *Rorschach* paintings, which document a comprehensive reckoning with the post-war belief in the collective unconscious.

With the "abstract" works, Warhol had dissociated himself from the sources of his earlier pictures and their commercial appearance to such an extent that they resulted in the beginnings of a new œuvre. The equally comprehensive series of *Camouflages*, which was begun in 1986 and included garishly colored examples in yellow, red, orange, blue, violet and pseudomilitary color patterns, may be viewed as his legacy, since Warhol also used the motif for self-portraits, portraits of Joseph Beuys, the *Statue of*

Liberty, and his last exhibited work, the *Last Supper* by Leonardo da Vinci. The series is not simply about the image of personal camouflage or a grotesque appropriation of the military design common as a decorative pattern since the Second World War. For, like the *Oxidations* and *Rorschachs*, the starting point lies in an alchemical search, in which an existing abstraction is appropriated as a historical subject, in order to plant a tiny visual holy relic in a world of consumption, which knows only illusions and not faith.

In comparison with the five series of paintings named above, the small group of *Eggs* of 1982 were conceived as Easter gifts. The first examples, given to friends or colleagues, were all in small formats. Warhol produced only a single group in a larger size.[32] All of the other "abstract" works follow the guiding principle of aloofly and fleetingly embracing an essentially familiar pictorial object in order to establish it as part of an inventory of salable cultural goods.

In 1974, in honor of the art historian and artists' friend Meyer Schapiro, Warhol had a black rectangle printed over one of his *Campbell's Soup Cans* designs, so that his own "trademark" appeared to be obliterated by a modernist emblem in the tradition of Kazimir Malevich and Ad Reinhardt.[33] There was also a gesturally vehement portrait of his colleague David Hockney that glowed like sky-blue swimming-pool water,[34] so that years before the series discussed here began, there were already signs that Warhol was well acquainted with the iconography of "Suprematism," with the "black square pictures," and with expressive painting as a "sort of living," as De Kooning once put it.

With the *Oxidations*, on the other hand, the privatization and commercialization of highlights of American art history took on a hedonistic form rather than a systematic one. As in Hans Namuth's film of Jackson Pollock, Warhol spread primed canvas on the studio floor, in order to work on it from above and from all sides. In a kind of farce, he confided to his diary in the early summer of 1977 that his friend Victor Hugo was taking a lot of vitamin B so that "the canvas turns a really pretty color when it's his piss."[35] Male visitors left behind "drippings" on the copper base which produced ivylike structures and left a biomorphic mark. Women, who had to bend backwards over the surface of the painting, tended to evoke instead—as a consequence of this lack of range—"Stained Canvases" in the style of Morris Louis or abstract landscapes with round, lumpy patches as in Helen Fran-

kenthaler's work. Though Warhol forced himself to consume enormous quantities of fluids, he still found his physical limit was two turquoise-colored, oxidized testimonials a day.[36] Victor Hugo has confirmed the existence of several *Come* paintings, made with ejaculations, which Warhol mentioned in his diary several times, in contrast to almost all his other artworks. One of the *Come* paintings was given as a gift to the actor Richard Gere, though he burned it in his fireplace the following day.[37]

The *Shadows* were produced concurrently with the *Oxidations* in 1978 and 1979. For the former, Warhol used flamelike and girder-shaped silhouettes, which were enlarged and combined with a single bright color. Similar motifs in black and white had been made famous by the blocklike shapes on the paintings of Motherwell and Kline. In place of expressive single images, Warhol presented a series; in place of an abstract gesture that emphasized the center, there were chiaroscuro motifs along the edge of the painting. In contrast to the New York School, the bright colors left the breadth of the canvas flat and empty. By varying the color of the otherwise similar shadow motifs, Warhol produced a staccato of quivering contrasts. At the exhibition of the *Shadows* in 1979 at the Heiner Friedrich Gallery in New York (now the Dia Center for the Arts), the paintings hung like a frieze just above the floor with flaming silhouettes and strong colors. Visually, Warhol was presenting an unusually autonomous work, but he did not personally wish to confer all his faith in it. Cynically, he remarked that the presentation only looked that good because it was so large.[38]

The *Rorschach* paintings of 1984 used no specific source to clarify this method of interpreting personality.[39] As always, the work began with generally known images; in this case, the original tests were symmetrical, butterflylike shapes, which, despite the largely arbitrary application of color, were used to interpret one's "personality" or "life". A great deal of value was attributed to the method, particularly in Pollock's creative development.[40] Warhol had experimented with Rorschach pictures at an early age while still at school.[41] He exceeded his own standards in the extent of the formats, producing black and gold *Rorschachs* nearly fourteen feet high and nine and a half feet wide in a larger set. Besides experiments on small canvases with a wide spectrum of colors, ranging from pink, white, grey, red, yellow, green, and turquoise to violet, these works were limited to a classical form, with black or gold on a white or gold base. At

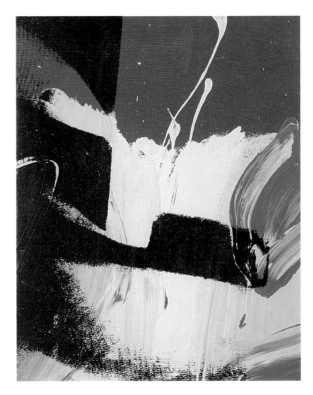

Shadow. 1978.
Synthetic polymer paint and silk-screen ink on canvas.
14 x 11 in. (35.5 x 28 cm)

first a pencil line marking the border of the figure was used as the basis for the application of the paint before the canvas was folded in half. The production of later examples was left more to chance. Warhol tried out both saturated and weakly colored figures and sometimes had the paint smeared on while it was still wet. Warhol never stipulated which side of these works was top or bottom.

An exhibition of the *Rorschachs* at the Mary Boone Gallery was discussed, but nothing came of it. The series eventually became known through an exhibition at Leo Castelli's gallery and, after Warhol's death, two examples were included in the retrospective presented in 1989 at the Museum of Modern Art in New York.[42] With the *Rorschachs*, too, whose form is flat and color monosyllabic, Warhol's autonomous hedonism questions our idea of "hight art." The emptiness of the *Oxidations* and *Shadows* appears as with the *Rorschachs* in a seductively simple, cheerful monumentality, which displays the nihilism of his work as a form of faith.

With the *Camouflages* of 1986, the famous danger faced by Abstract Expressionism, that of turning into "apocalyptic wallpaper," the reproach Harold Rosenberg had made of the "American Action Painters" as early as 1952,[43] was taken literally and used as a starting point. Six years after the shimmering, iridescent, and seemingly endlessly repeatable *Reversals* of his own early work, Warhol launched another wallpaperlike series of paintings, which was based visually on an abstraction of nature developed for the military. "Effects" counted above all else for Warhol, as Crone said in 1988 at a symposium.[44] What could produce more effects than graduated contrasts with continual repetition in extremely large formats?

Very early on, with his peach and soup cans, Warhol had reacted to a world of products devoid of a metaphysical background that sought astonishment and consumption, and then withdrew himself from it by means of reproductions that were exaggeratedly crude or contained inaccurate finishing touches. The imperfections grew into a style, and the mechanics became an ideal of productivity. To this end, Warhol altered and extended the apparatus of his printing techniques, in order to include all the possibilities of enlargement, reduction, excerpting, reflection, refraction, and collage into his assembly-line work. With the *Camouflages*, a military pattern that helped to hide weapons of war in the landscape[45] was brought into play for an abstract, informal flood of paintings. Warhol expanded the veg-

etablelike effect of leaf-shaped sprigs and islands, first onto square, then onto rectangular formats, until the "all-over" ideal of the Abstract Expressionists had been brought back to its familiar origin: the water-lily paintings of Claude Monet. This historically burdened design was brightened and lightened by colors to such an extent that we stand in front of it almost devoutly, as if in front of some spiritually emphatic testimony to abstract painting, ready to lose ourselves in the over thirty-five-foot wide *Camouflages* as in a landscape. They cause us to forget Warhol's image worship. Their brightness and their radiance remind us without irony or satire of Pollock's "dripping" or Monet's *Nymphéas* (Water Lilies). In their impudence, the *Camouflages* also reach toward the "luxurious" works of Henri Matisse that Warhol loved.

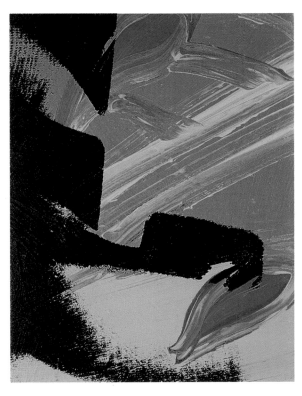

Shadow. 1978.
Synthetic polymer paint and silk-screen ink on canvas.
14 x 11 in. (35.5 x 28 cm)

Notes

1 Crone called the politically forced result "Warhol's first abstract painting." Rainer Crone, *Andy Warhol*, Teufen, 1970, p. 11; figs. p. 200 f.

2 Kynaston McShine points to Barnett Newman's *Cathedra* of 1951 in this context. Cf. "Introduction," in: McShine (ed.), *Andy Warhol: A Retrospective*, New York, 1989, pp. 16 f.

3 Robert Rosenblum, "Warhol as Art History," ibid., p. 27.

4 Ibid., p. 28.

5 Crone 1970, pp. 10 f., 54.

6 Robert Rosenblum, "Andy Warhol: Court Painter to the 70s," in: David Whitney (ed.), *Andy Warhol: Portraits of the '70s*, New York, Whitney Museum of American Art, 1979, pp. 9–20.

7 Hilton Als polemicized against the style, which he claimed was based on Warhol's "sissy preoccupations" with the named objects (cited according to Victor Bockris, *The Life and Death of Andy Warhol*, New York, 1989, p. 78).

8 Crone 1970, jacket flap text and p. 9.

9 Franz Meyer, in his introduction to the catalogue *Warhol Maos*, Kunstmuseum Basel, 1972 (no page number).

10 Peter Weibel, "Super-Artist Andy Warhol: Porträt des Pappa der Pop-Art," in: *Film*, vol. 6, no. 5 (May 1968), p. 19.

11 Crone 1970, p. 11.

12 Ibid., p. 29.

13 G. R. Swenson, "What is Pop Art? Answers from Eight Painters, Part I: Jim Dine, Robert Indiana, Roy Lichtenstein, Andy Warhol," in: *Art News*, vol. 62, no. 7 (November 1963), p. 26.

14 Henry Geldzahler, "Some Notes on 'Sleep'," in: *Film Culture*, no. 32 (Spring 1964), p. 13.

15 "Andy Warhol: Interviewed by Gerard Malanga", in: *Kulchur*, no. 16 (Winter 1964/65), pp. 37 f.

16 See note 14 above.

17 As, for example, Hans Strelow, "Alles ist einfach, alles ist Kunst: Ein Gespräch mit dem amerikanischen Pop-Künstler Andy Warhol in Stockholm," in: *Frankfurter Allgemeine Zeitung*, 14 March 1968.

18 Jürgen Harten, "Dreissig sind besser als eines: In Stockholm begann eine grosse Andy-Warhol-Ausstellung," in: *Die Zeit*, 16 February 1968.

19 Crone 1970, p. 29.

20 Ibid., pp. 307–12. The licensing of Warhol images is now handled by Hendrik te Neues on the basis of a contract with the Andy Warhol Foundation for the Visual Arts. "These products bring in more than ten million dollars in a single year," wrote the *Frankfurter Allgemeine Zeitung* in connection with a film review (no. 175, 31 July 1993, p. 24).

21 Mary Fuller, "An Ad Reinhardt Monologue," in: *Art Forum*, vol. IX, No. 2 (October 1970), p. 38.

22 "I mean, being with a creative crowd, you really know the difference," Warhol said, for example, in November 1984; cf. Pat Hackett (ed.), *The Andy Warhol Diaries*, New York, 1989, p. 614 f. On his encounters with Basquiat, Clemente, Haring, Schnabel, and others of the new generation of New York artists, cf. ibid., pp. 434, 462, 468, 483, 492, 502, 503, 520, 521, 532, 548, 579, 626, 627, 636, and passim.

23 "...they're all like me, so similar, and so peculiar, but they're being so artistic and I'm being so commercial that I feel funny. I guess if I thought I were really good I wouldn't feel funny seeing them all," Warhol said in March 1977 (ibid., p. 33).

24 Ibid., p. 343 (see also note 23 above).

25 Ibid., p. 513. Warhol felt that his experiences at Madonna's spectacular wedding on 16 August 1985 in Los Angeles made for the most interesting weekend of his life (ibid., p. 670).

26 Ibid., p. 23.

27 Ibid., p. 780.

28 Swenson 1963, p. 26. On the historical background of the antisubjective attitude, cf. the catalogue *Blam! The Explosion of Pop, Minimalism and Performance, 1958–1964*, New York, Whitney Museum of Art, 1984, p. 77–87.

29 "I don't want to get too close; I don't like to touch things, that's why my work is so distant from myself." Andy Warhol, *The Philosophy of Andy Warhol (From A to B and back again)*, New York, 1975, p. 62. Warhol's friend Charles Lisanby, with whom he made a trip around the world in 1956, described this characteristic in more detail; cf. Bockris 1989, p. 81.

30 Hackett 1989, p. 44.

31 The behavior of the previous generation of painters is satirically described in Andy Warhol and Pat Hackett, *POPism: The Warhol '60s*, New York and London, 1980, pp. 14 f. Warhol had expressed a "hatred" of Abstract Expressionism to Leonard Kessler; cf. Bockris 1989, p. 97.

32 I am grateful to Timothy Hunt, the curator of the Andy Warhol Foundation for the Visual Arts, for information on each of the six groups of "abstract" paintings. The *Eggs* of 1982 had been preceded by smaller works with chocolate bunnies and other Easter gifts.

33 Cf. McShine 1989, plate 312, p. 300.

34 Ibid., plate 332, p. 315.

35 Hackett 1989, p. 55.

36 Ibid., p. 174.

37 Ibid., p. 539. Warhol had given the painting in 1983 to Jean-Michel Basquiat, who gave it to Gere shortly thereafter.

38 Ibid., p. 200.

39 The original edition by Dr. Hermann Rorschach was published in Bern and Leipzig in 1921.

40 Because of his alcoholism, Pollock had submitted himself for psychoanalysis, from 1937 on, to two students of Carl Jung, who also gave him Rorschach tests. His "psychoanalytical drawings" were published as a book in 1970 (New York) and discussed and illus-

trated repeatedly in New York art magazines: *Artforum* in November 1972, *Arts Magazine* in March 1979, and *Art in America* in November/December 1979. For more on this topic, see William Rubin, "Jackson Pollock illustrateur jungien: les limites de la critique psychologique," in the catalogue *Jackson Pollock*, Paris, Centre Georges Pompidou, 1982, pp. 325–48.

41 Robert Nickas, "Andy Warhol's Rorschach Test," in: *Arts Magazine*, October 1986, pp. 28–29.

42 McShine 1989, pp. 31, 76, 382 f. (plates 422–24).

43 Harold Rosenberg, "The American Action Painters," in: *Art News*, vol. 51, no. 8 (December 1952), p. 49.

44 Cf. Gary Garrels (ed.), *The Work of Andy Warhol*, Dia Art Foundation, Discussions in Contemporary Sculpture, no. 3, Seattle, 1989, p. 134.

45 Arshile Gorky, Gyorgy Kepes, and Clyfford Still had worked with military camouflage for the U.S. Army during the Second World War. Alighiero e Boetti used this piebald military pattern in 1966 for a painting titled *Mimetico*. General remarks on soldiers' attempts to blend in with natural colors are given in Martin Warnke, *Politische Landschaft: Zur Kunstgeschichte der Natur*, Munich and Vienna, 1992, p. 75 and n. 110.

List of Works

Oxidation Paintings 1978

Mixed media on copper metallic paint on canvas
76 x 52 in. (193 x 132 cm) PA 45.135 Illustrated p. 31

Mixed media on copper metallic paint on canvas
76 x 52 in. (193 x 132 cm) PA 45.137 Illustrated p. 12

Mixed media on copper metallic paint on canvas
76 x 52 in. (193 x 132 cm) PA 45.139 Illustrated p. 30

Mixed media on copper metallic paint on canvas
76 x 52 in. (193 x 132 cm) PA 45.140 Illustrated p. 32

Mixed media on copper metallic paint on canvas
78 x 204 ½ in. (198 x 519.5 cm) Courtesy Thomas Ammann Fine Art, Zurich
Illustrated pp. 28 and 29

Shadow Paintings 1978/79

Silk-screen ink and diamond dust on synthetic polymer paint on canvas
78 x 50 in. (198 x 127 cm) PA 65.058 Illustrated p. 35

Silk-screen ink and diamond dust on synthetic polymer paint on canvas
76 x 52 in. (193 x 132 cm) PA 65.069 Illustrated p. 34

Silk-screen ink on synthetic polymer paint on canvas
76 x 52 in. (193 x 132 cm) PA 65.075 Illustrated p. 37

Silk-screen ink on synthetic polymer paint on canvas
76 x 52 in. (193 x 132 cm) PA 65.076 Illustrated p. 36

Silk-screen ink on synthetic polymer paint on canvas
80 x 192 in. (203 x 488 cm) PA 65.107 Illustrated pp. 38/39

Silk-screen ink on synthetic polymer paint on canvas
78 x 138 in. (198 x 351 cm) Courtesy Thomas Ammann Fine Art, Zurich
Illustrated p. 40

Egg Paintings 1982

Silk-screen ink on synthetic polymer paint on canvas
90 x 70 in. (229 x 178 cm) PA 19.003 Illustrated p. 44 and front cover

Silk-screen ink on synthetic polymer paint on canvas
90 x 70 in. (229 x 178 cm) PA 19.008 Back cover

Silk-screen ink on synthetic polymer paint on canvas
90 x 70 in. (229 x 178 cm) PA 19.009 Illustrated p. 43

Silk-screen ink on synthetic polymer paint on canvas
90 x 70 in. (229 x 178 cm) PA 19.010 Illustrated p. 42

Yarn Paintings 1983

Silk-screen ink on synthetic polymer paint on canvas
40 x 40 in. (102 x 102 cm) PA 22.024 Illustrated p. 49

Silk-screen ink on synthetic polymer paint on canvas
40 x 40 in. (102 x 102 cm) PA 22.025 Illustrated p. 49

Silk-screen ink on synthetic polymer paint on canvas
40 x 40 in. (102 x 102 cm) PA 22.026 Illustrated p. 50

Silk-screen ink on synthetic polymer paint on canvas
54 x 206 in. (137 x 523 cm) PA 22.027 Illustrated p. 46/47

Silk-screen ink on polymer paint on canvas
40 x 40 in. (102 x 102 cm) PA 22.028 Illustrated p. 48

Rorschach Paintings 1984

Synthetic polymer paint on canvas
120 x 96 in. (305 x 244 cm) PA 75.048 Illustrated p. 55

Synthetic polymer paint on canvas
164 x 114 in. (417 x 290 cm) PA 75.050 Illustrated p. 54

Synthetic polymer paint on canvas
164 x 115 in. (417 x 292 cm) PA 75.052 Illustrated p. 53

Synthetic polymer paint on canvas
164 x 115 in. (417 x 292 cm) PA 75.055 Illustrated p. 57

Synthetic polymer paint on canvas
158 x 110 in. (401 x 279 cm) PA 75.056 Illustrated p. 58

Synthetic polymer paint on canvas
164 x 115 in. (417 x 292 cm) PA 75.058 Illustrated p. 56

Synthetic polymer paint on canvas
90 x 70 in. (229 x 178 cm) PA 75.081 Illustrated p. 52

Synthetic polymer paint on canvas
94 x 68 in. (239 x 173 cm) PA 75.082 Illustrated p. 52

Camouflage Paintings 1986

Silk-screen ink on synthetic polymer paint on canvas
72 x 72 in. (183 x 183 cm) PA 85.022 Illustrated p. 63

Silk-screen ink on synthetic polymer paint on canvas
76 x 76 in. (193 x 193 cm) PA 85.027 Illustrated p. 61

Silk-screen ink on synthetic polymer paint on canvas
116 x 401 ½ in. (295 x 1020 cm) PA 85.031 Illustrated p. 67

Silk-screen ink on synthetic polymer paint on canvas
76 x 76 in. (193 x 193 cm) PA 85.038 Illustrated p. 60

Silk-screen ink on synthetic polymer paint on canvas
76 x 76 in. (193 x 193 cm) PA 85.040 Illustrated p. 62

Silk-screen ink on synthetic polymer paint on canvas
116 x 420 in. (295 x 1067 cm) PA 85.046 Illustrated pp. 64/65 and 66

Silk-screen ink on synthetic polymer paint on canvas
50 x 198 in. (127 x 503 cm) PA 85.065 Illustrated pp. 68 and 69

Silk-screen ink on synthetic polymer paint on canvas
50 x 198 in. (127 x 503 cm) PA 85.069 Illustrated pp. 70 and 71

Camouflage, 1987

Portfolio of eight silk-screen prints,
each 38 x 38 in. (96.5 x 96.5 cm) Not illustrated

Plates

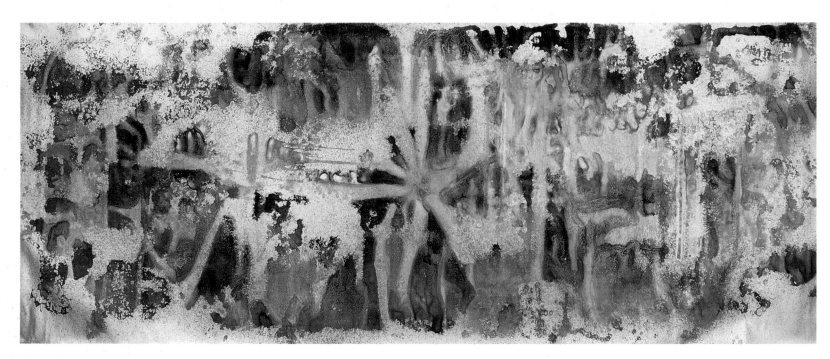

78 × 204½ in. (198 × 519.5 cm) Courtesy Thomas Ammann Fine Art, Zurich

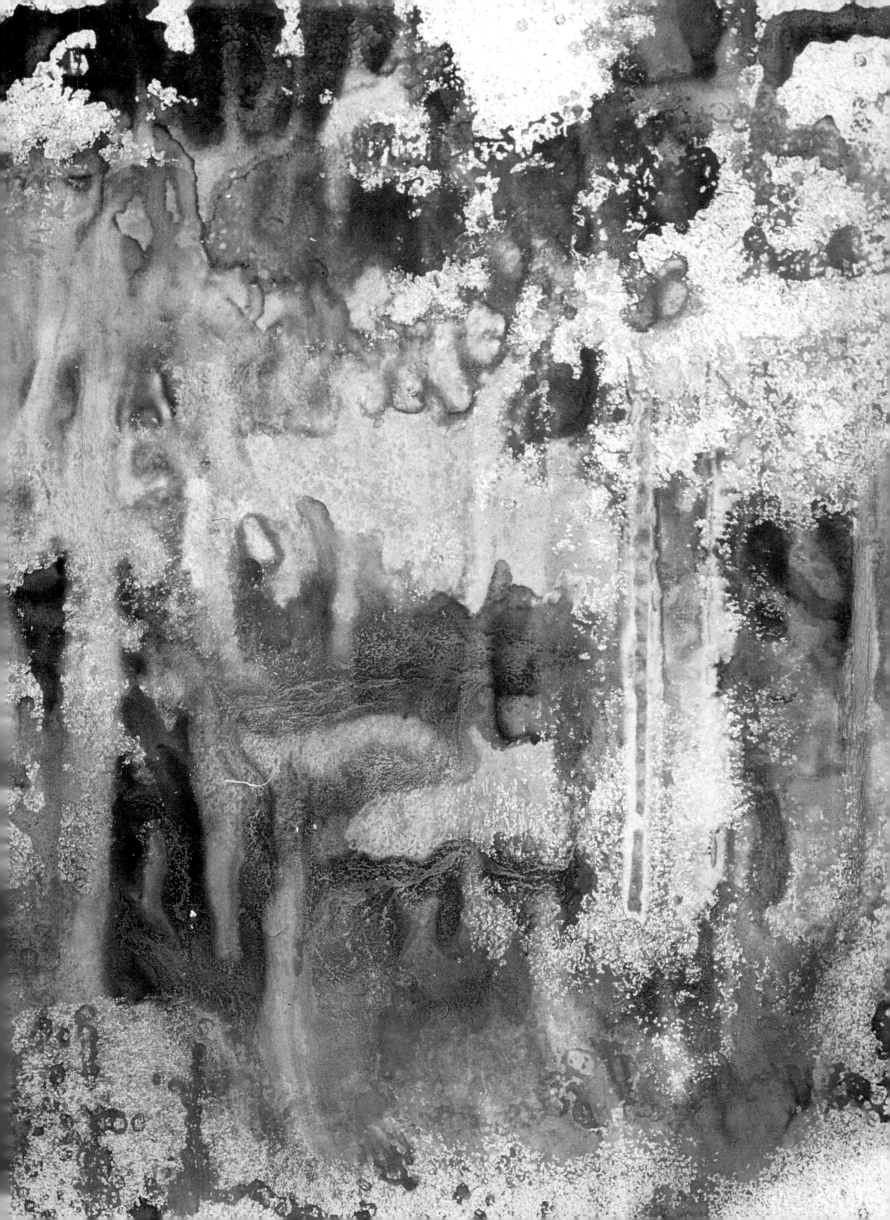

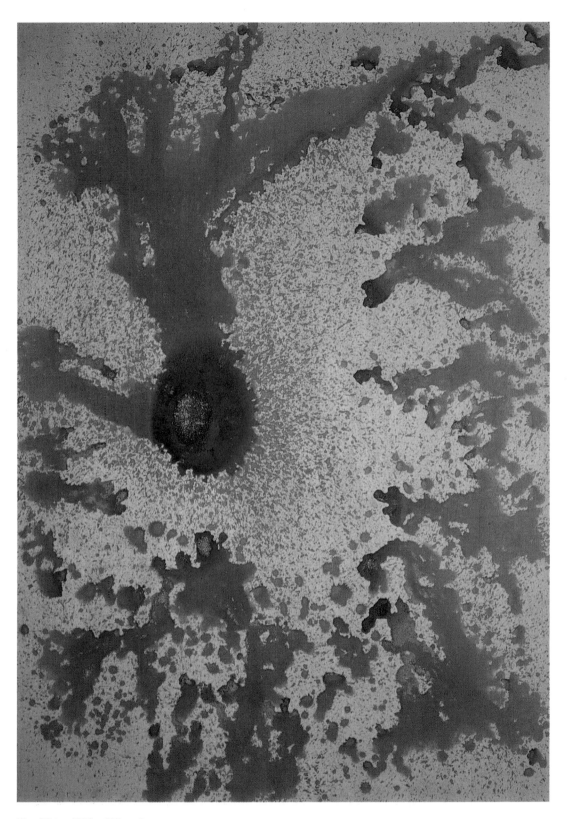

76 x 52 in. (193 x 132 cm)

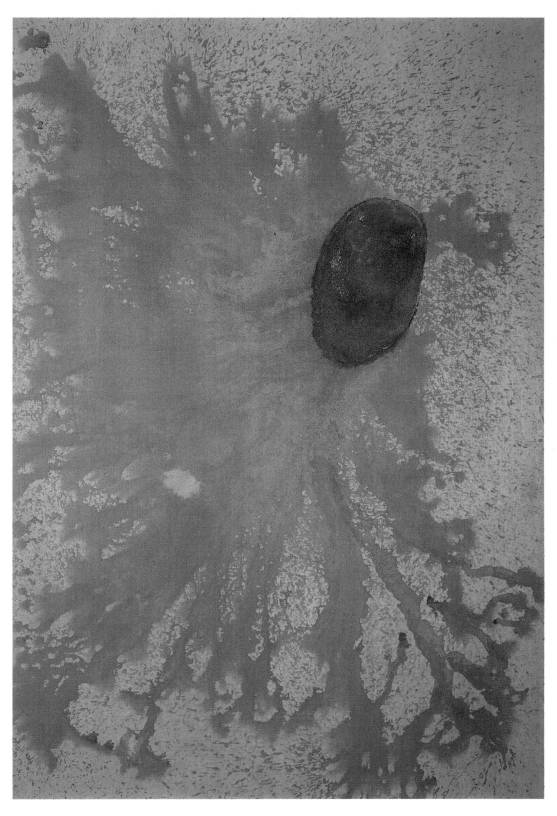

76 x 52 in. (193 x 132 cm)

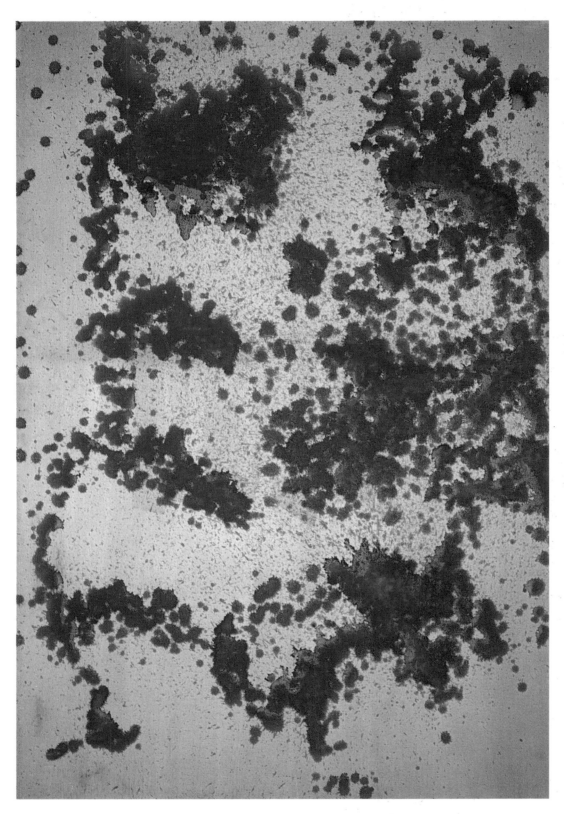

76 x 52 in. (193 x 132 cm)

Shadow Paintings

For his *Shadows* of 1978 and 1979, Warhol turned photo-graphs of silhouettes of unidentifiable objects into silk screens that were used along with paints of various colors and dia-mond dust. The majority of the paintings are either 84 x 64 in. (213 x 163 cm) or 14¼ x 11 in. (36 x 28 cm), and the colors range from silver-grey, anthracite, and white to yellow, red, green, and blue. The abutted arrangement of the works at their first exhibition in New York in 1979 resulted in a three-dimensional, environmental effect, reminiscent of billboards or streetlights.

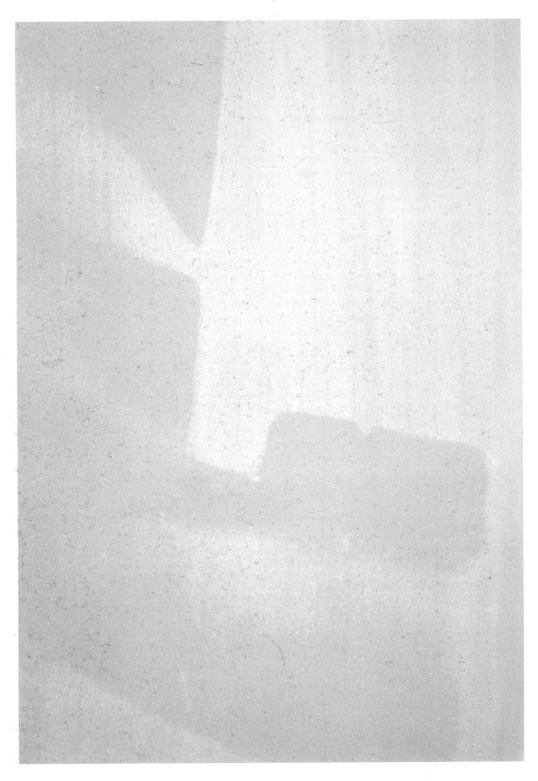

76 x 52 in. (193 x 132 cm)

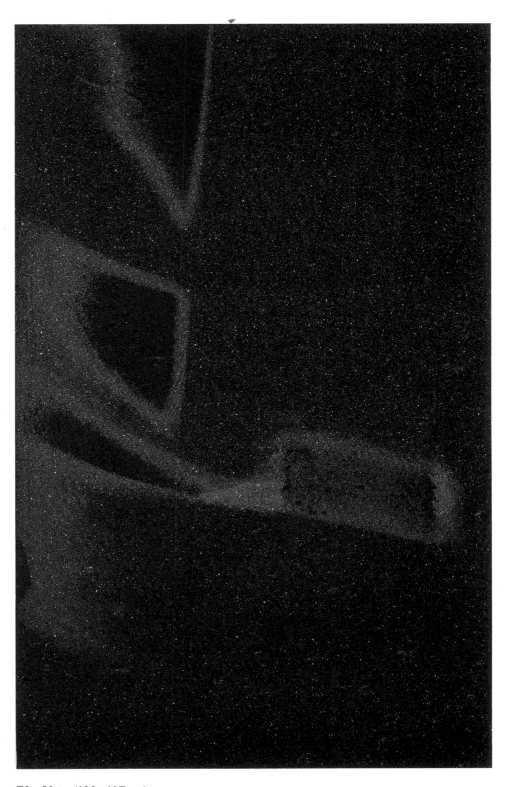

78 x 50 in. (198 x 127 cm)

76 x 52 in. (193 x 132 cm)

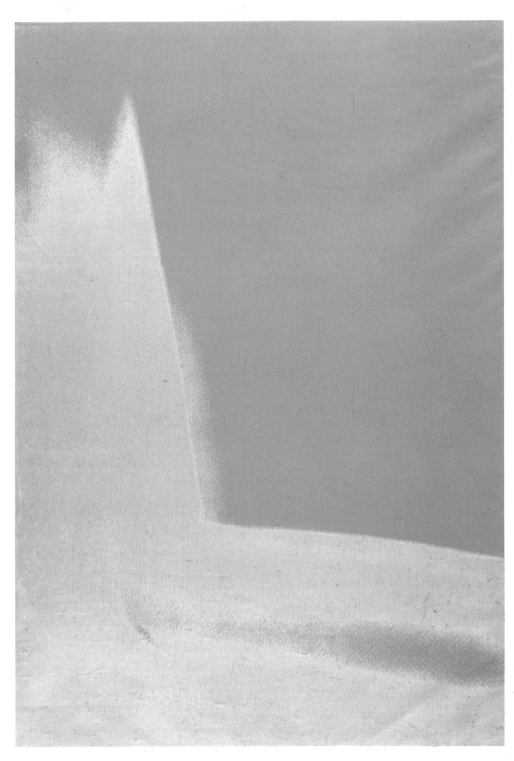

76 x 52 in. (193 x 132 cm)

80 x 192 in. (203 x 488 cm)

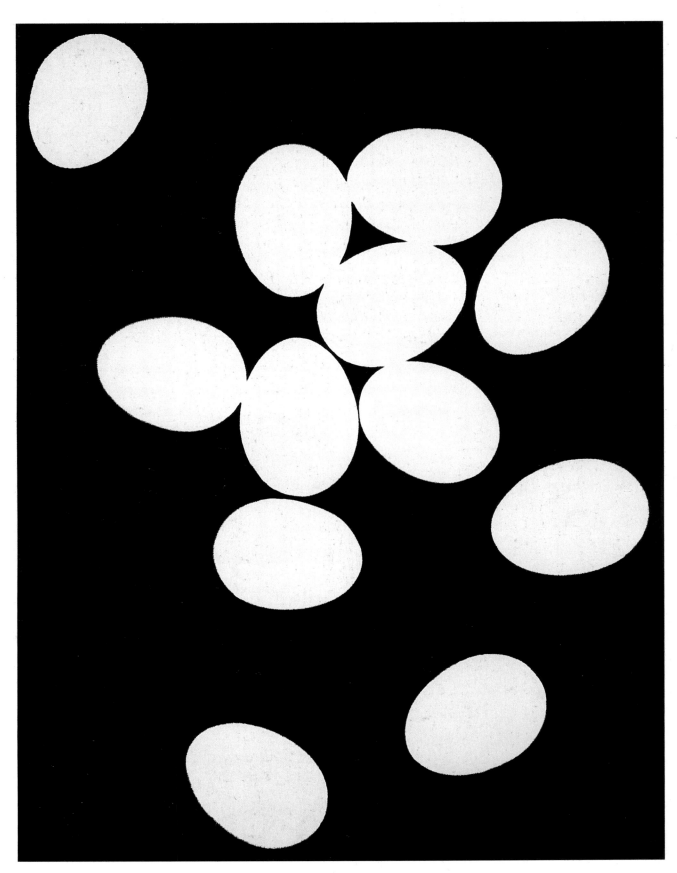

90 x 70 in. (229 x 178 cm)

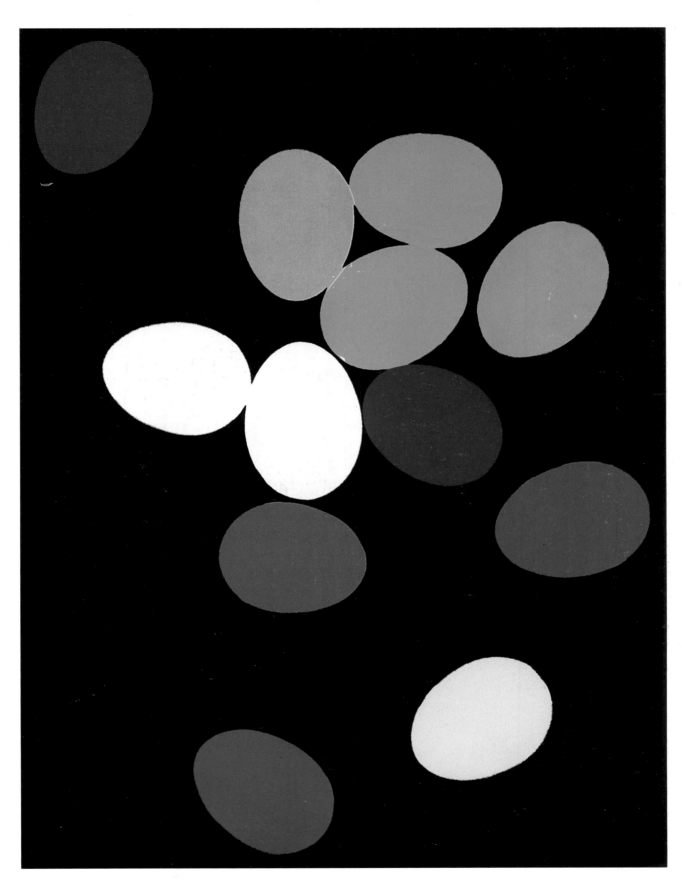

90 x 70 in. (229 x 178 cm)

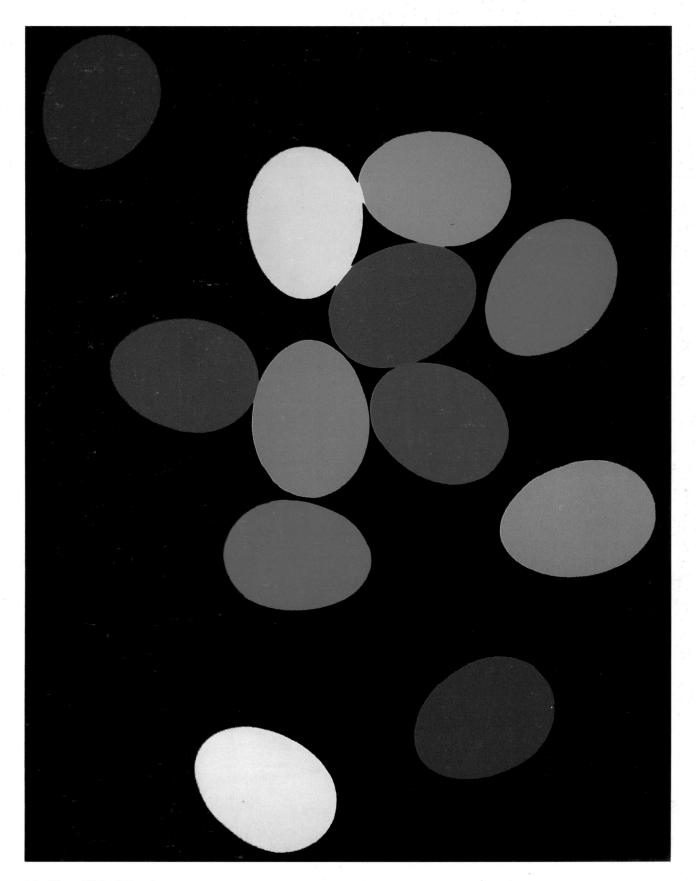

90 x 70 in. (229 x 178 cm)

Yarn Paintings

The *Yarn* paintings of 1983 are as little known as the *Egg* paintings, and even more rare. The series was commissioned by an Italian textile company. With the luminosity and complexity of these paintings, Warhol once again referred to the heroic works of Jackson Pollock from the years 1949 and 1950. A mechanically reproduced photograph of a yarn pattern, printed in several colors on top of and next to one another, accumulates into a filigreed, "clean" net of an alternative "all-over" painting. That photographic blurring is evident in the completed works—a consequence of the reduction in color intensity—reveals the mischievous humor in Warhol's ideas of abstraction.

54 x 206 in. (137 x 523 cm)

40 x 40 in. (102 x 102 cm)

Rorschach Paintings

Warhol created his own "Rorschach test" dozens of times with his assistants in 1984. The test had been popular in the U.S. since the Second World War, with artists and others, as a means of testing and interpreting impulses from the unconscious. Pink, white, grey, red, yellow, green, purple, and turquoise tests in small formats were traditionally used whereas Warhol achieved the more classical, butterfly-shaped results of his abstract works in the large-format paintings in black, white, and gold shown on the following pages.

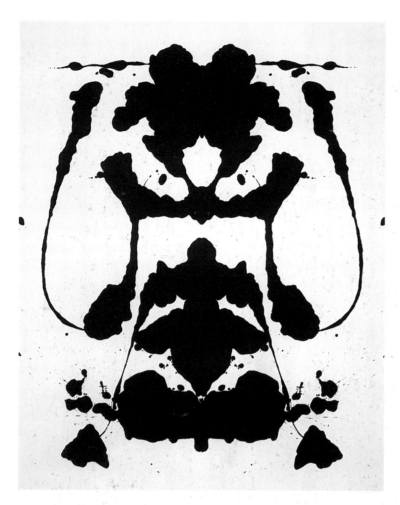

90 x 70 in. (229 x 178 cm)

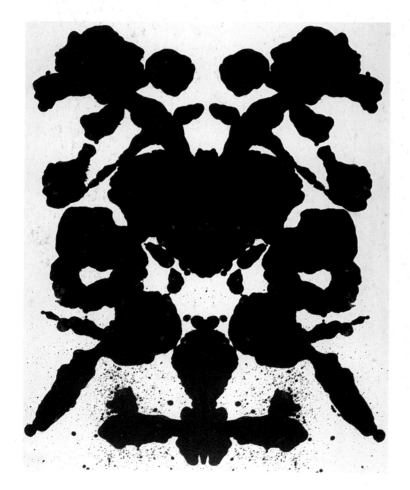

94 x 68 in. (239 x 173 cm)

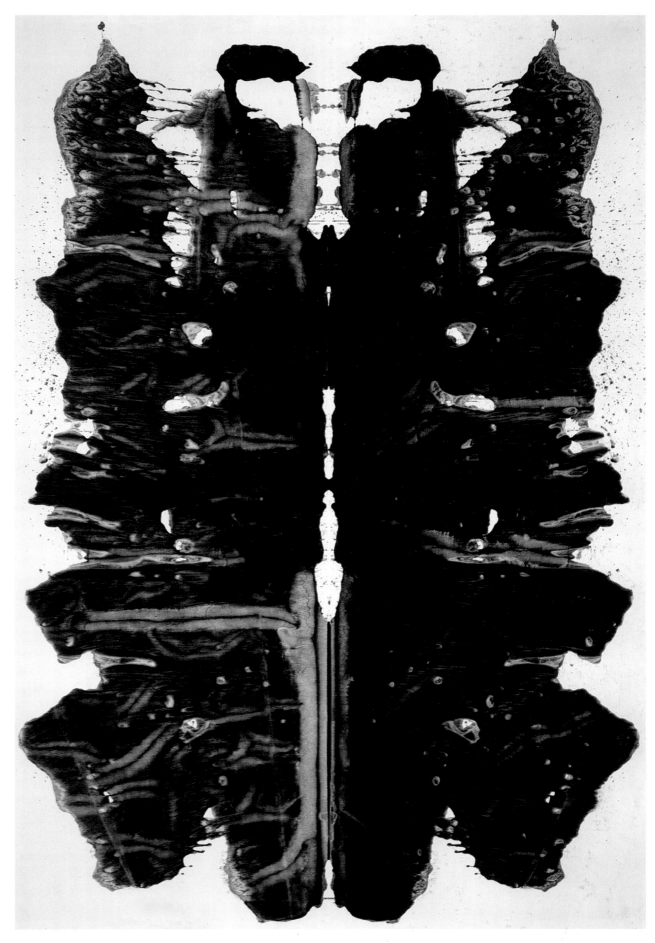

164 x 115 in. (417 x 292 cm)

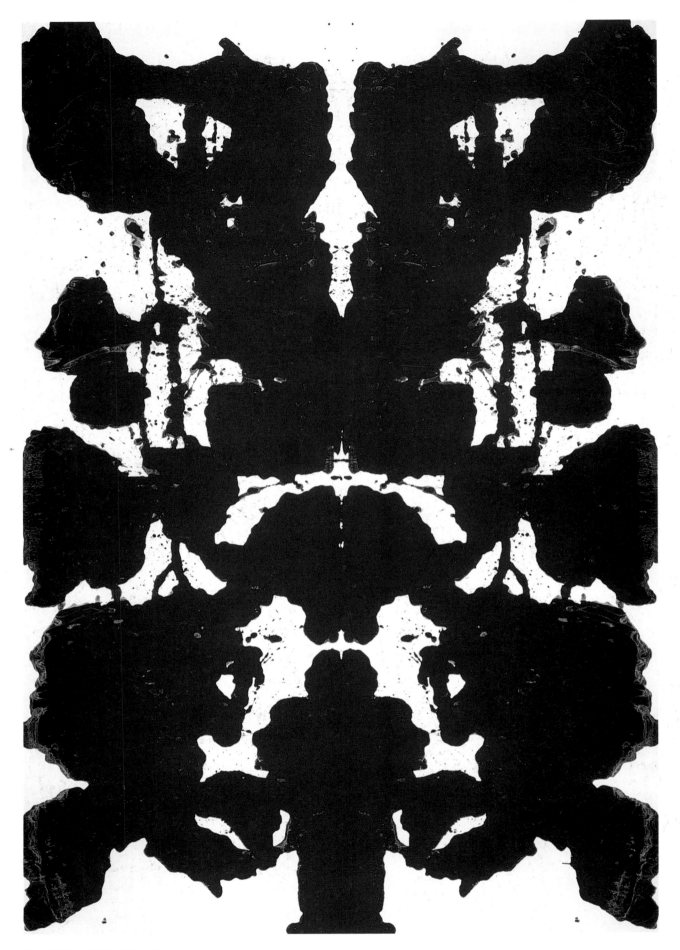

164 x 114 in. (417 x 290 cm)

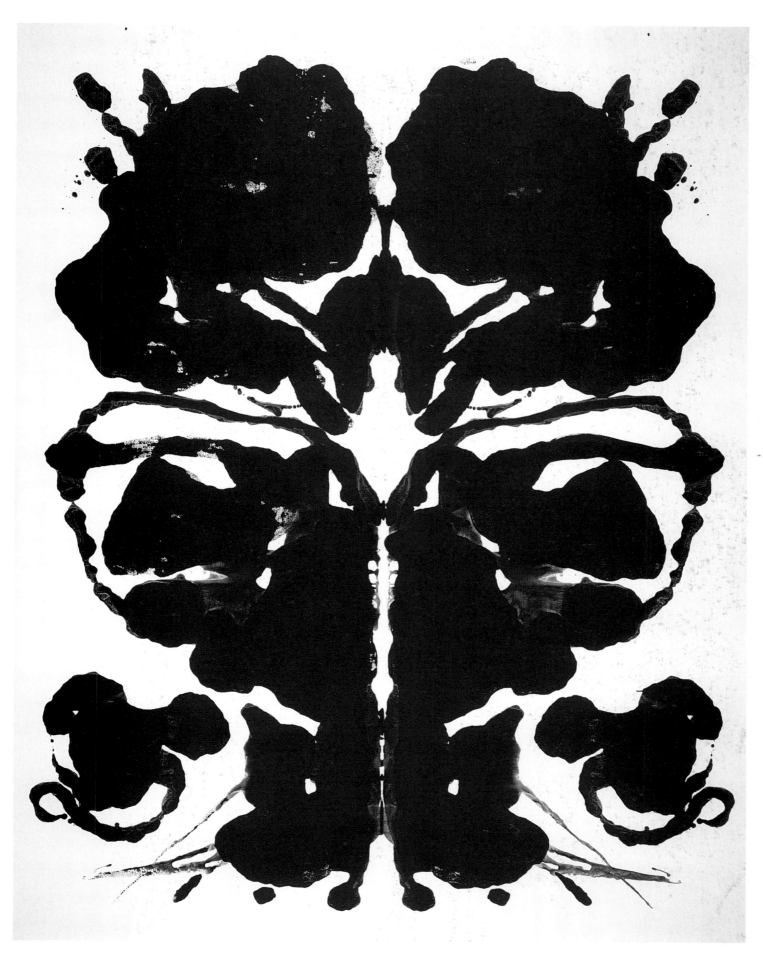

120 x 96 in. (305 x 244 cm)

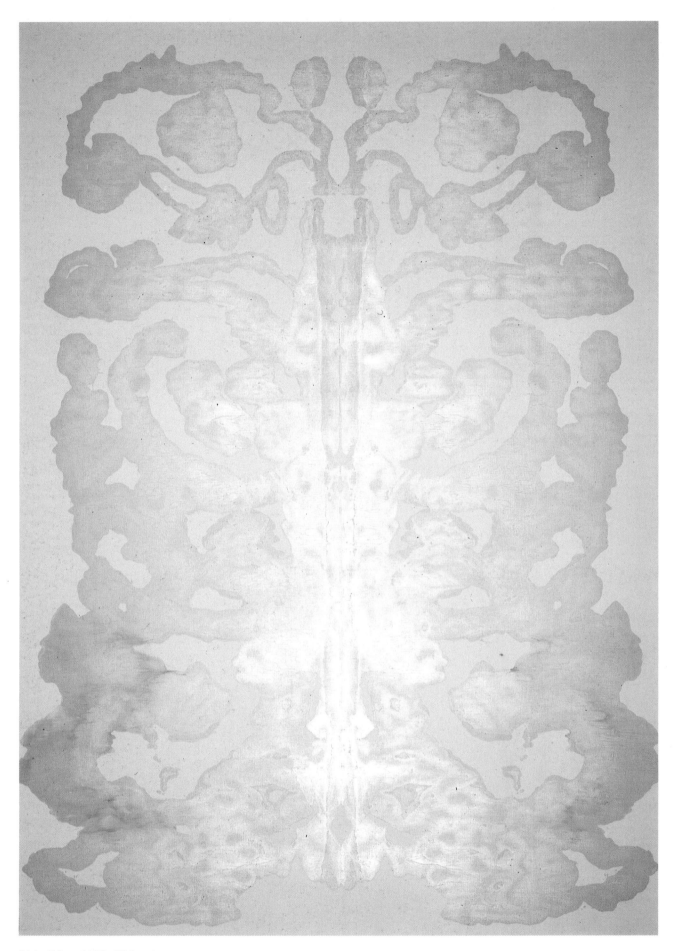

164 x 115 in. (417 x 292 cm)

56 Rorschach Paintings

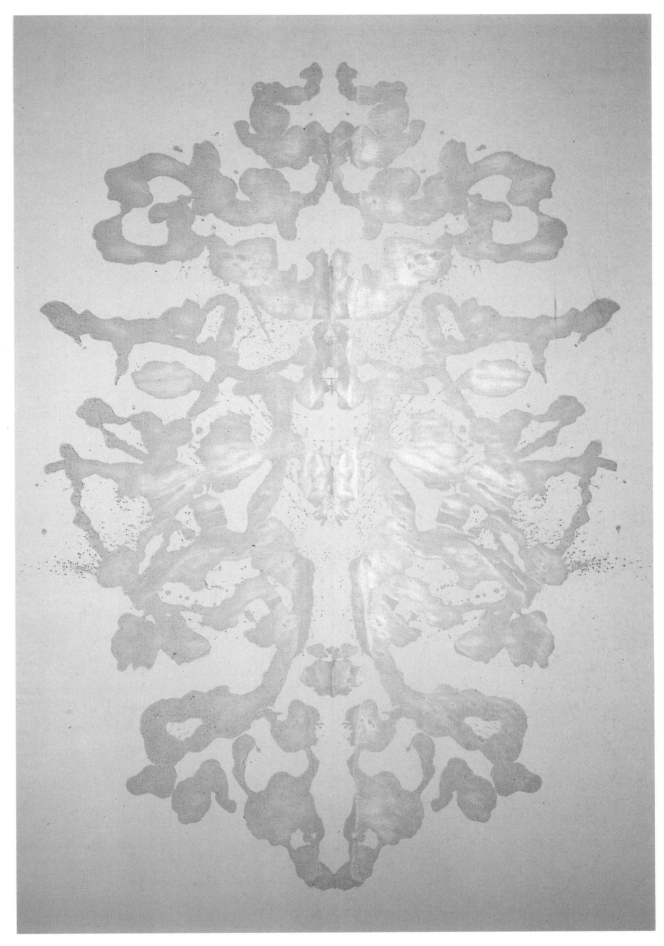

164 x 115 in. (417 x 292 cm)

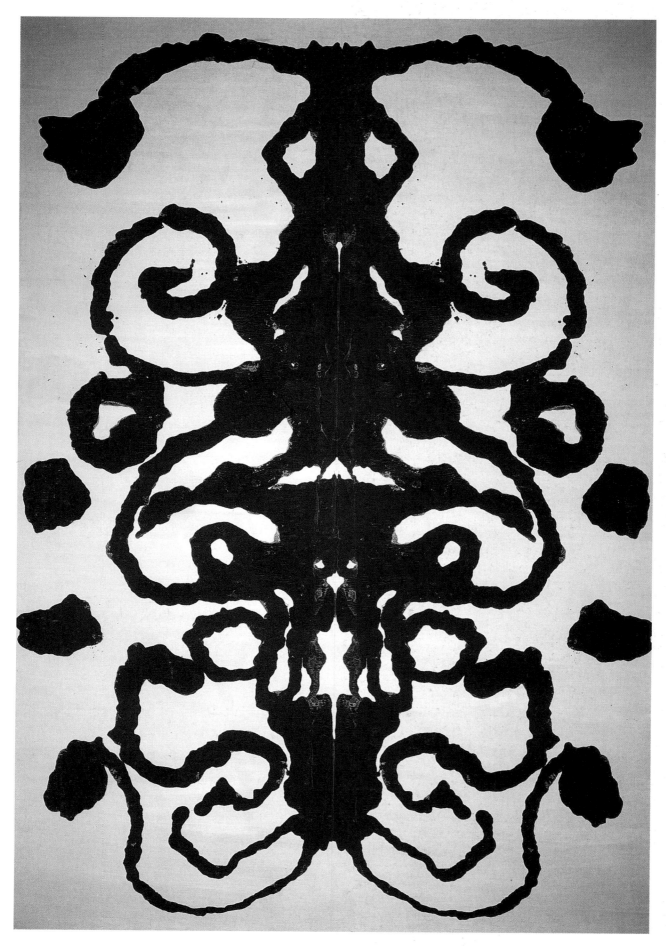

158 x 110 in. (401 x 279 cm)

Camouflage Paintings

Warhol's belated contribution to the large-scale paintings characteristic of the masterpieces of Abstract Expressionism came in the form of the imposing dimensions of his *Camouflages* of 1986. Slightly different patterns based on curvilinear forms were printed in various colors and shades, resulting in paintings nearly ten feet high and thirty-five feet wide. In 1987, in addition to the manifold examples of the series on canvas, a portfolio of eight screen prints was published.

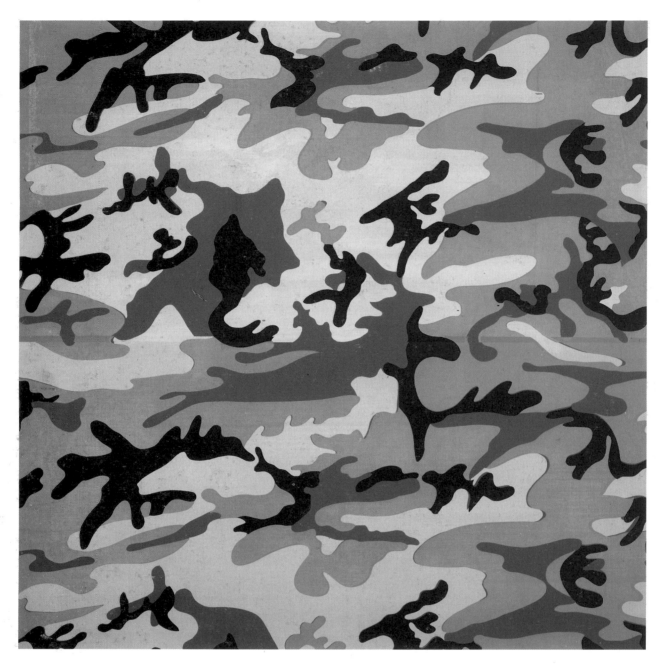

76 x 76 in. (193 x 193 cm)

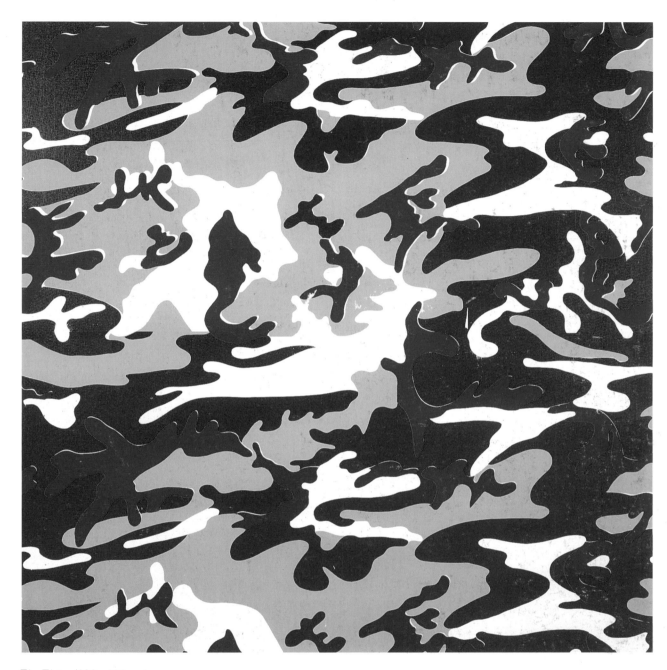

76 x 76 in. (193 x 193 cm)

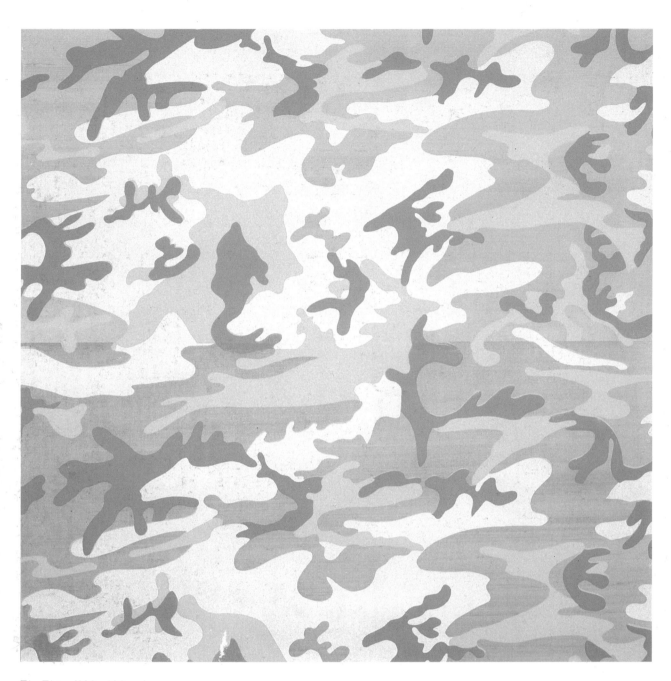

76 x 76 in. (193 x 193 cm)

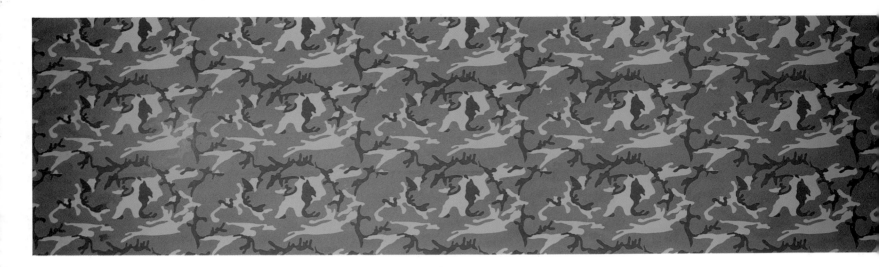

116 x 420 in. (295 x 1067 cm)

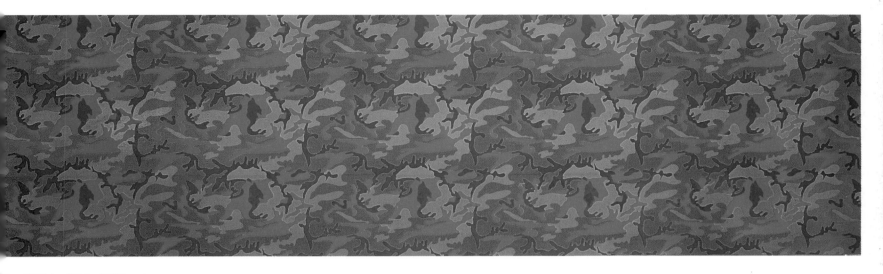

5 x 401½ in. (295 x 1020 cm)

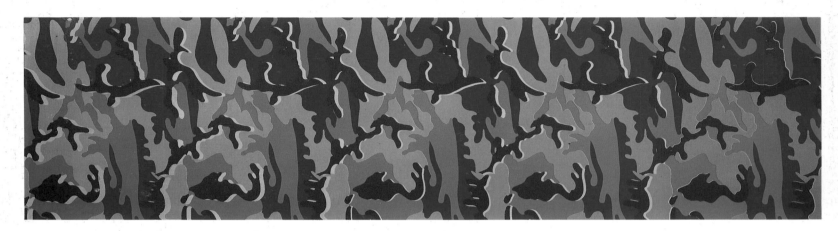

50 x 198 in. (127 x 503 cm)

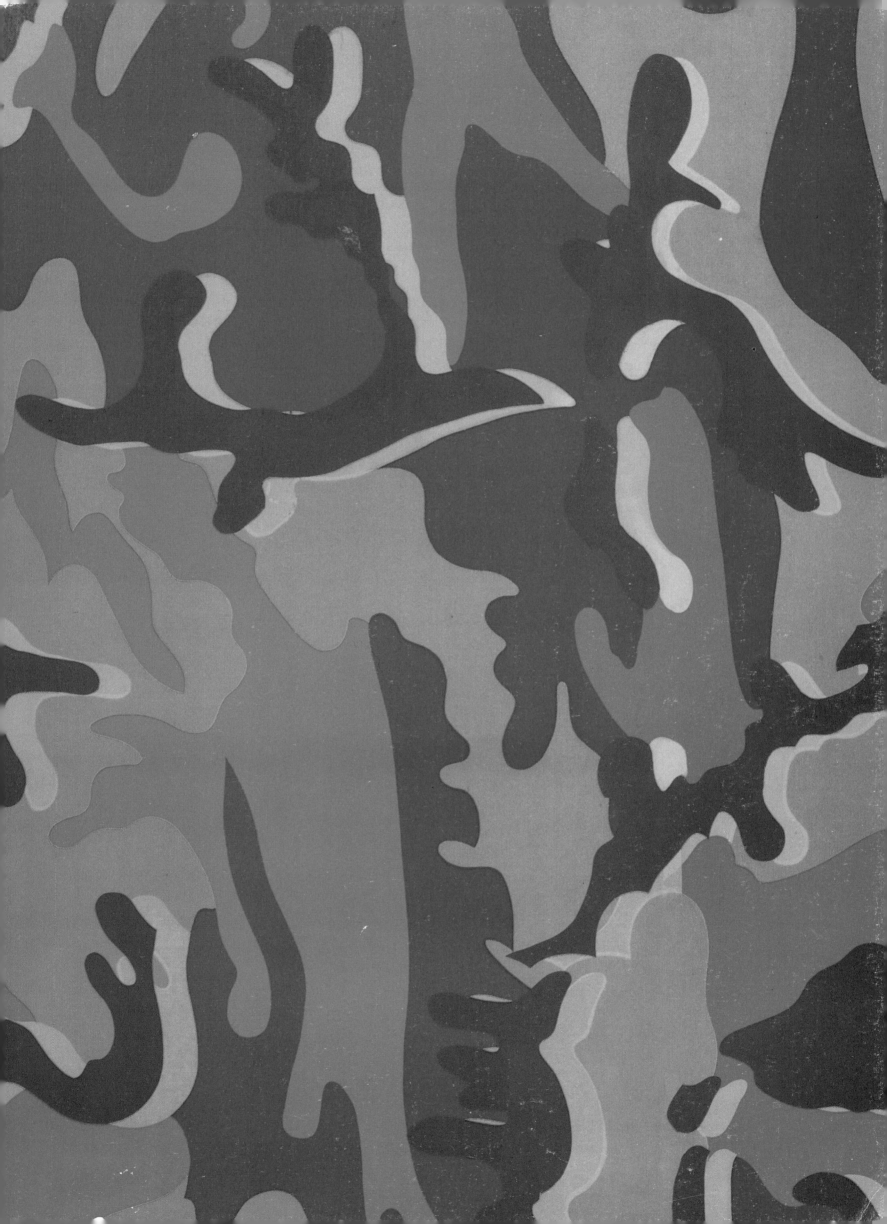

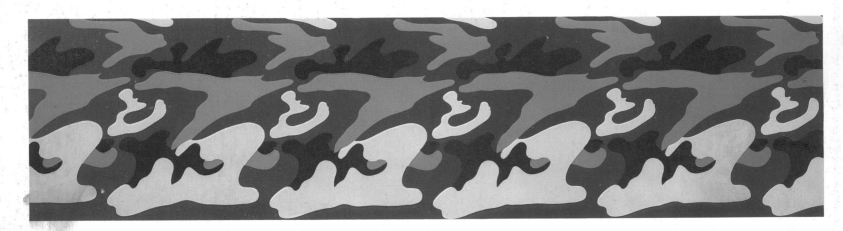

50 x 198 in. (127 x 503 cm)

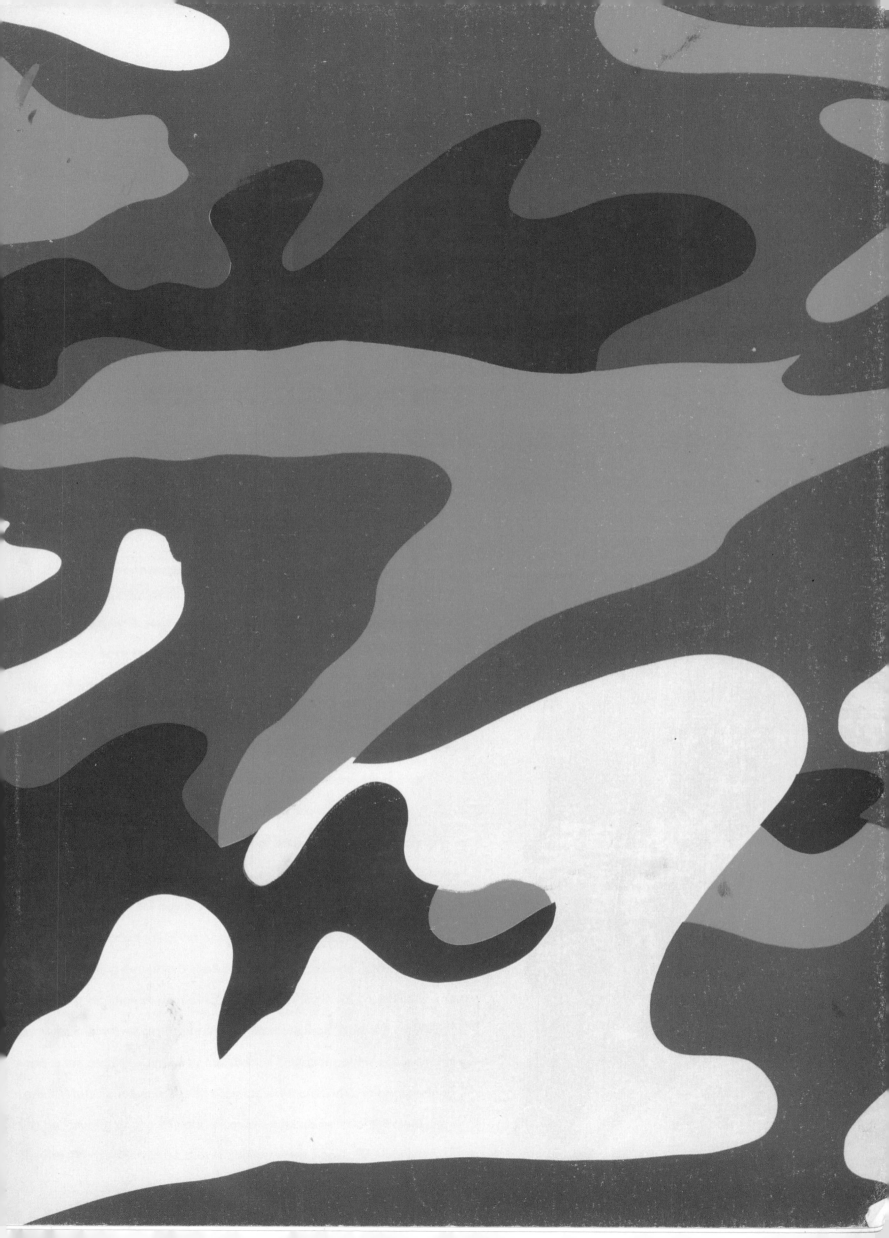

however, Warhol abandoned the shorter, edited shot as a unit of his film-making, and turned instead to the single-shot roll. From now on, in nearly all of his early films, each shot would last for the entire length of that roll of film; in other words, each roll would contain only one shot. Warhol extended this simplification even further in his films *Blow Job* and *Eat* (both shot in the winter of 1963–64), in which a single stationary shot is continued through multiple rolls to record a single, preconceived action. *Blow Job* (whose title is an integral part of the film) shows the face of a young man leaning against a wall while, somewhere below the film frame, the action indicated by the title takes place out of sight of the viewer. The film is a perfect piece of wit, parodying with its explicit title and frustrating framing the conventions and expectations of pornography and censorship. It is also an extraordinary film portrait, in which the young man's face, dramatically lit from above and constantly changing with his passions, begins to evoke an iconography of portraiture, suggesting at different times the radiance of Raphael or the brooding intensity of James Dean.

Eat (1963) is a portrait of the Pop artist Robert Indiana, whose series of sign-like *Eat* paintings inspired the action of the film. Indiana, seated in a chair with a rubber plant in the background, faces the camera and very slowly, as directed by Warhol, nibbles at a single mushroom. The action of the film, already extended by Indiana's languorous chewing and by the slow motion of its projection, is rendered even more mysterious by Warhol's decision to assemble the nine 100-foot rolls out of order, so that the mushroom magically renews itself and is never fully consumed. The film is a true portrait: watching Indiana eating for thirty-five minutes, one becomes aware of the self-possession with which he faces the eye of the camera, an equality of gaze mirrored by that of his cat, who makes a brief appearance in the film.

In *Empire* (1964), Warhol extended his single-shot, single-roll concept even further by renting a 16-mm Auricon camera, which would take 1,200-foot lengths of film to produce a single, eight-hour shot of the Empire State Building. The absence of any perceptible action and the immobility of the film's "star" (*Empire* is the only Warhol film whose subject is not a person) are further exaggerated by the extreme time distortion created by its slow-motion projection, which extends the five and a half hours of footage to a full eight hours. The result is a film which, in its utter stillness and duration

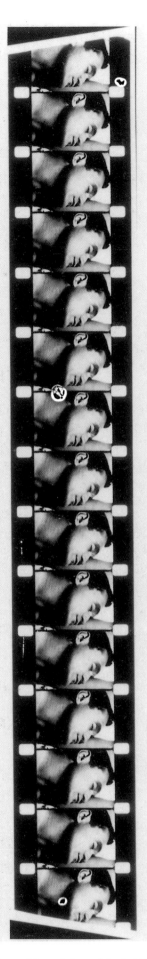

John Giorno in *Sleep*, 1963. © 1990 The Estate and Foundation of Andy Warhol

on the screen, becomes equivalent in physical presence to a painting on the wall. In a sense, *Empire* is the successful realization of the eight-hour film Warhol failed to complete in *Sleep*. It is also the apotheosis of his minimal cinema; by the end of 1964, Warhol was turning his attention primarily to the making of narrative sound films.

In *Henry Geldzahler* (1964), shot the day after *Empire*, on the same rented Auricon camera, Warhol experimented with extending the length of the portrait film. Geldzahler, who was a curator at the Metropolitan Museum of Art, New York, and a close friend of Warhol's, was asked to sit on the couch at the Factory and do nothing but look at the camera and smoke a cigar for the sixty-six minutes it took to shoot the film. It is interesting that Warhol decided to make a silent, slow-motion portrait film of a man whose identity resided primarily in his verbal intelligence. The tension created by this minimal approach creates a fascinating exploration of character, as Geldzahler becomes increasingly uncomfortable under the camera's unyielding scrutiny.

1 "Nothing to Lose," interview with Gretchen Berg, *Cahiers du Cinema in English*, no. 10, May 1967, p. 40.

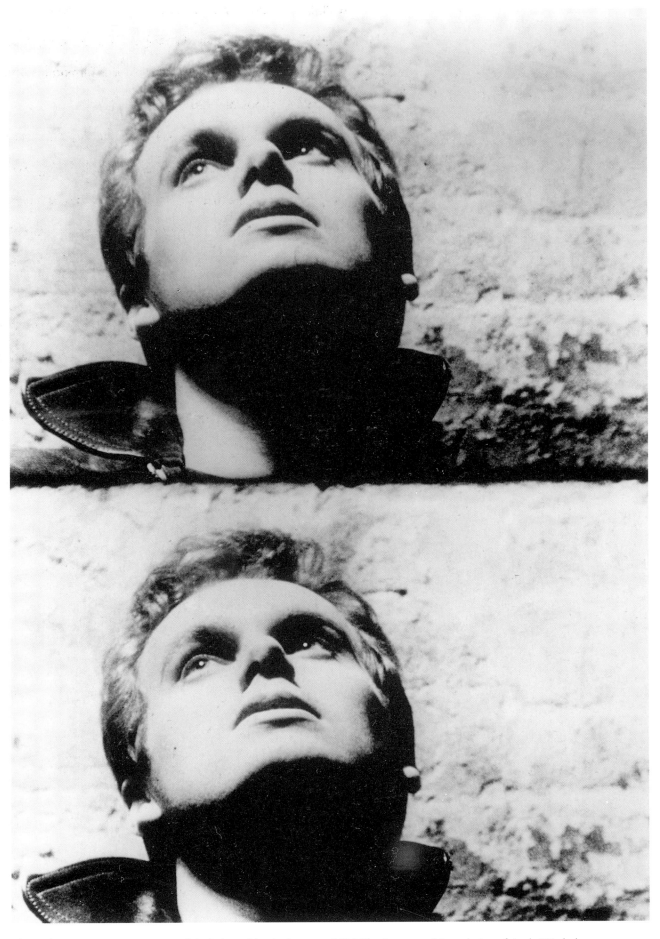

Blow Job, 1963. Frames courtesy of Anthology Film Archives. © 1990 The Estate and Foundation of Andy Warhol

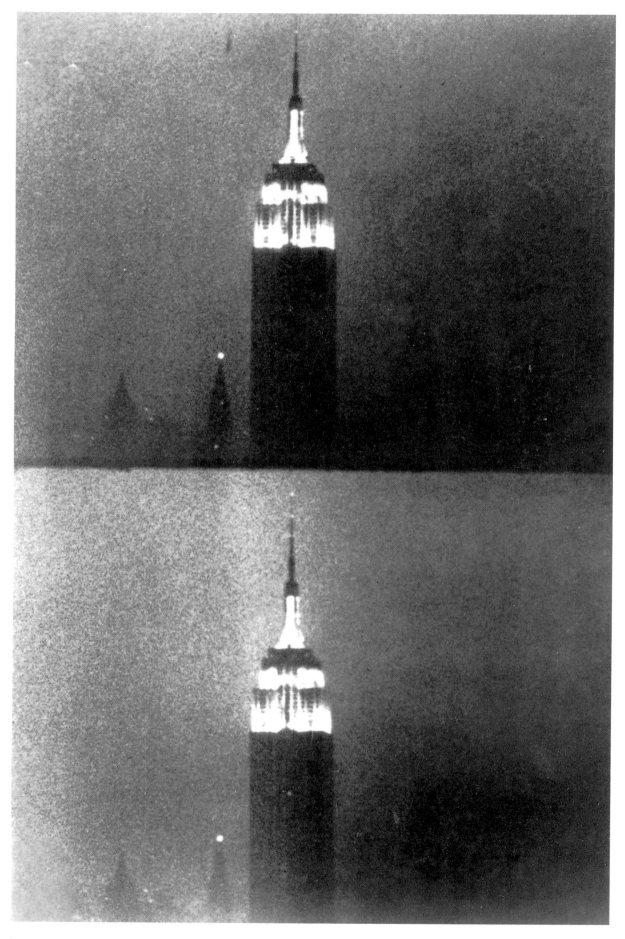

Empire, 1963. Frames courtesy of The Museum of Modern Art/Film Stills Archive.